THIS BOOK TO

esting.

School (1)

IN THE IN THE IN THE IN THE

Made in the USA Monee, IL 15 December 2020